Paintings by

Bob Ross®

T0364024

ISBN 978-0-7624-9041-7

Edited by Cindy De La Hoz
Designed by Ashley Todd
Cover illustration by Mario Zucca
Typography: Gill Sans and Knightsbridge
Paint stroke image © Thinkstock.com/zoom-zoom

Published by Running Press
Book Publishers,
An Imprint of Perseus
Books, LLC,
A Subsidiary of Hachette
Book Group, Inc.
2300 Chestnut Street
Philadelphia, PA 19103-4371

www.runningpress.com

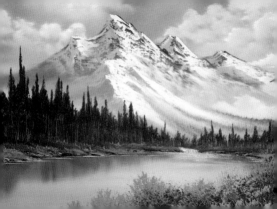

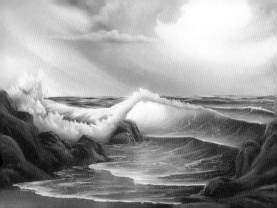

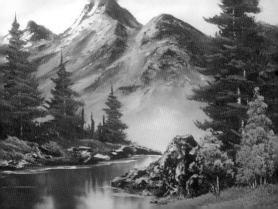

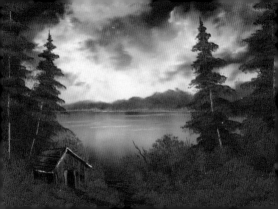

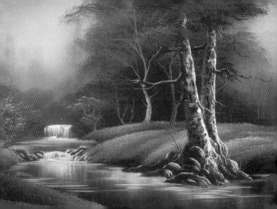

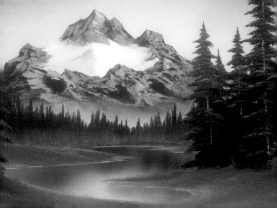

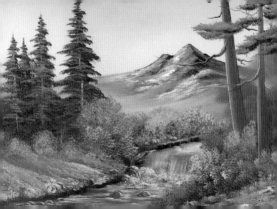

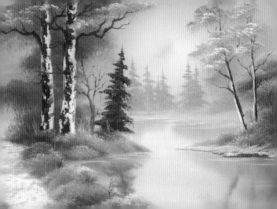

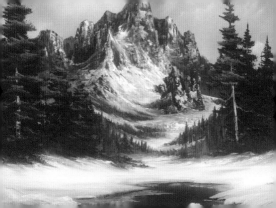

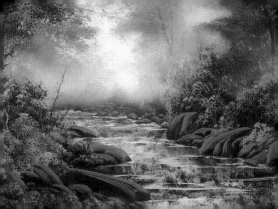

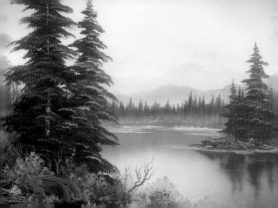

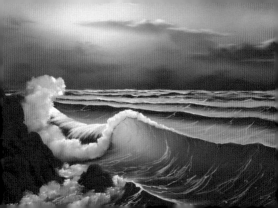

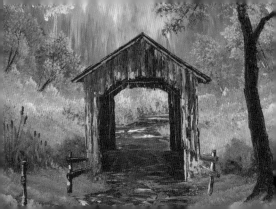

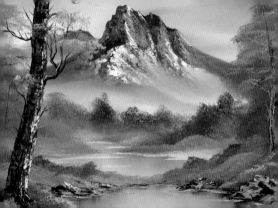

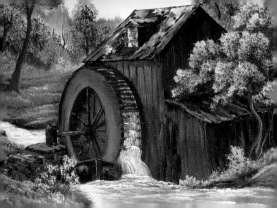

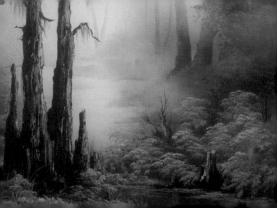

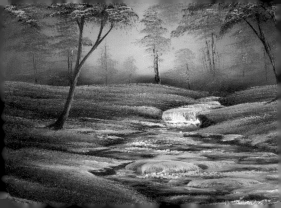

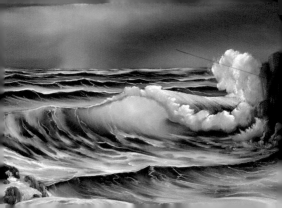

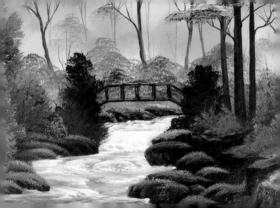

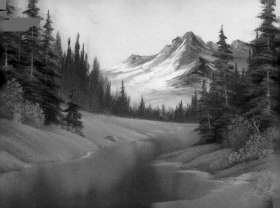

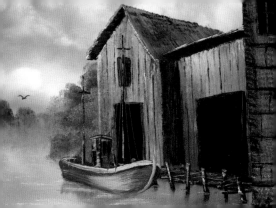

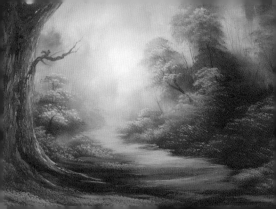

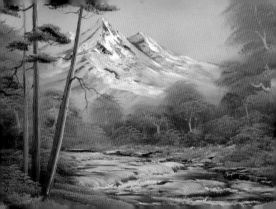

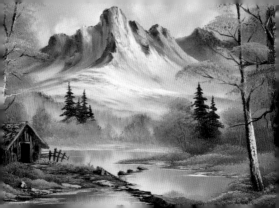

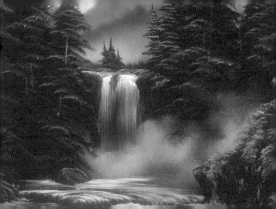

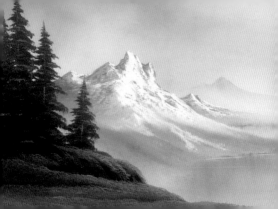

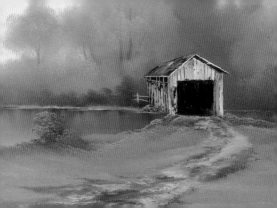

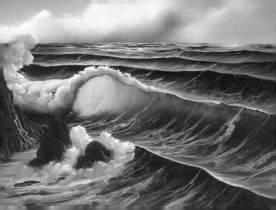

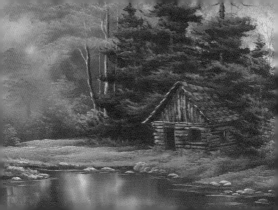

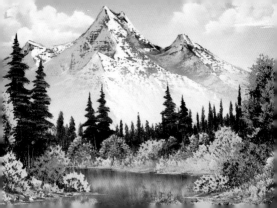